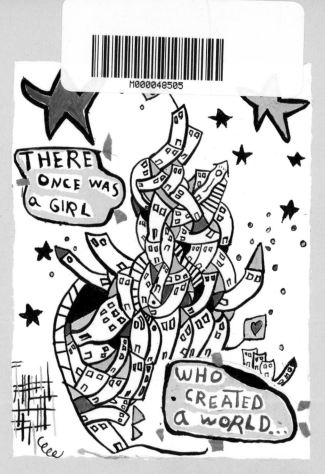

LOUISXXX

Andrews McMeel
PUBLISHING®

THIS BOOK WAS
WRITTEN AS
AS EVENTUALLY
AS POSSIBLE
AT——

Powder
FRENCH
studio
AND
THE
TREE HOUSE
**IN LOS ANGELES**

and in
cafes
in PARIS,  LØUIS XXX——

**SARL JAI KRISHNA**
KRISHNA BHAVAN
24 RUE CAIL 750° 0 PARIS
(100% PURE VEGETARIEN)
EMPORTES
10-08-2014
N° TABLE 8

| | |
|---|---|
| 1 NES CAFE | 1.50 |
| 1 EXTRA RICE | 3.00 |
| 1 PALAK PANEER | 5.00 |
| Total | 9.50 |

**TOTAL EUR: 9.50**

Dont TVA 10%          0.86

-- RCS PARIS 530 735 166--
MERCI DE VOTRE VISITE A BIENTOT

MARDI 19-08-2014 17:32:25
Cle 12-Serv : 12-CAISSE
MERCI DE VOTRE VISITE
A BIENTOT

**TOTAL**
EMPORTE
**10.00**

COLETTE
213 RUE ST HONORE
75001 PARIS

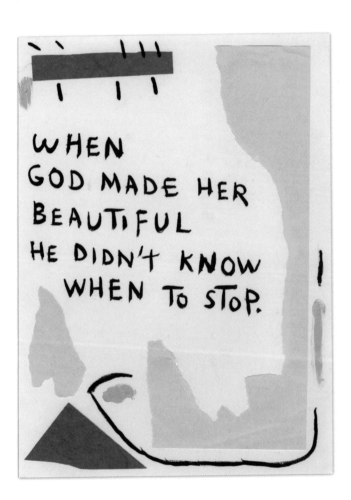

WHEN
GOD MADE HER
BEAUTIFUL
HE DIDN'T KNOW
WHEN TO STOP.

She sleeps with her
back to the window

starlight gently covers
her and keeps her
warm...

morning...sitting on the stairs

~~morning~~...Rubbing her eyes...

waiting for tea to cool

and she said...

"life is so big and beautiful...
what should we do next? ♡"

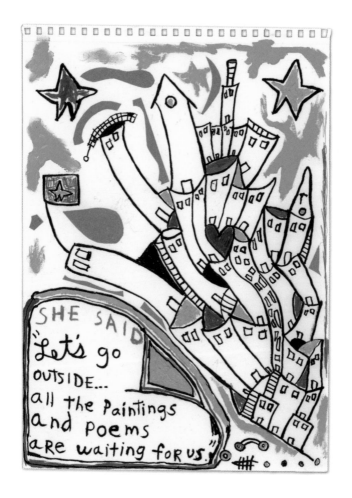

15

# LOVE AT FIRST SIGHT...

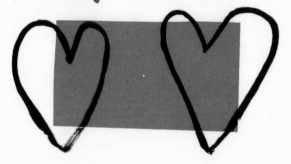

2 HEARTS SAYING "PLEASE TAKE ME WITH YOU."

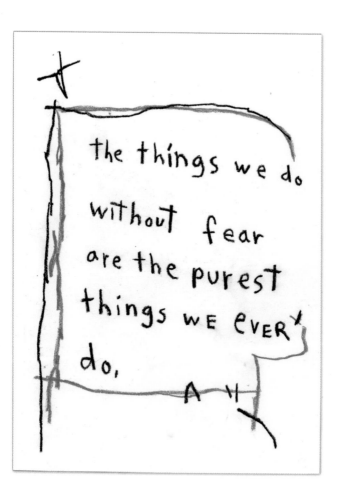

the things we do
without fear
are the purest
things we ever
do.

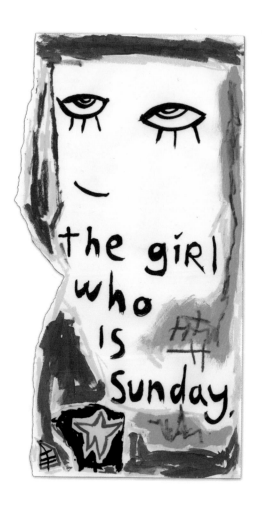

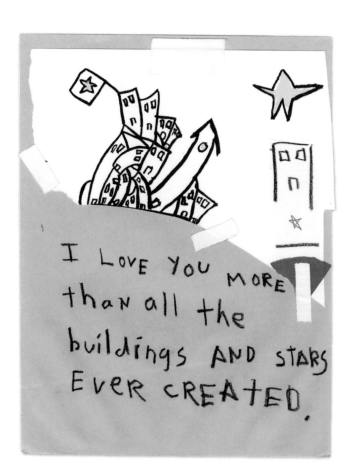

I LOVE YOU MORE than all the buildings AND STARS EVER CREATED.

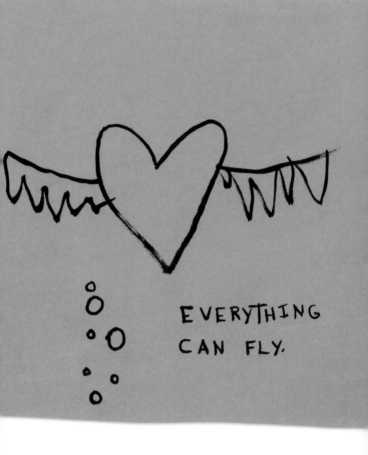

EVERYTHING
CAN FLY.

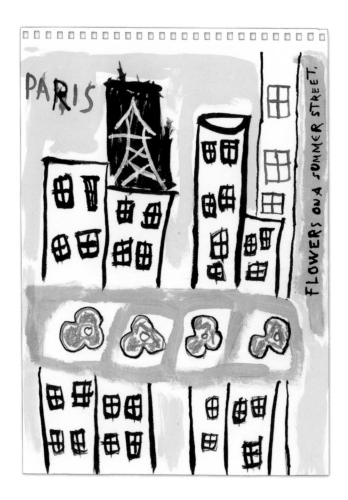

# taxis and sidewalks

SOMETIMES WE WALK
SOMETIMES WE RIDE.

we mostly walk.

SLEEPLESS ON A SUMMER Night.

candle lit walls

SHADOWS ALL AROUND US
BuT NEVER BETWEEN us,

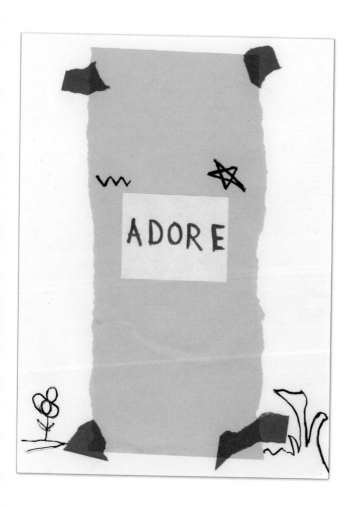

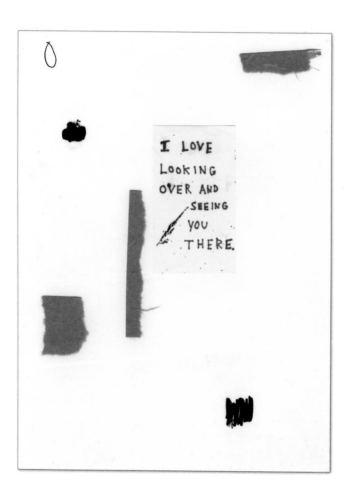

I LOVE
LOOKING
OVER AND
SEEING
YOU
THERE.

HEARTS ARE GOOD
AT FINDING OTHER
HEARTS.

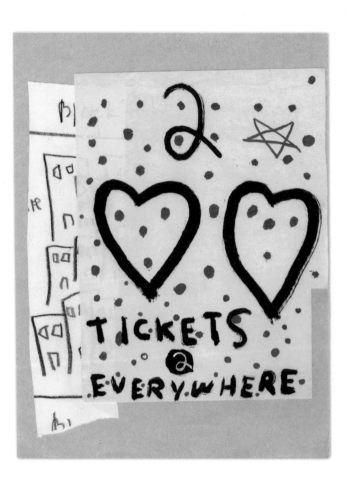

39

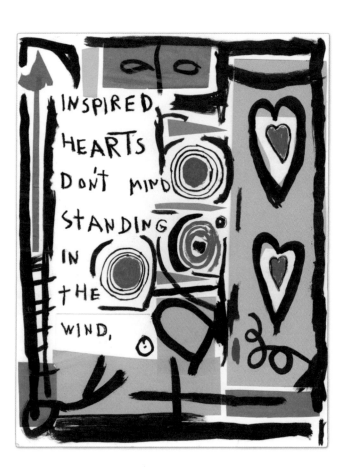

OUR
silhouette
against our
favorite
movie poster.
——————→ ⭐

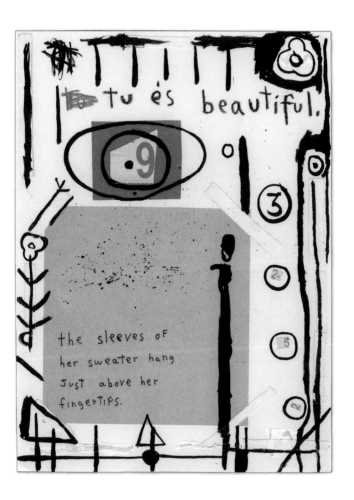

tu és beautiful.

the sleeves of
her sweater hang
just above her
fingertips.

to kiss HER
AND hold HER IS one THING
BUT
WHEN thoSE EYES
OF HERS
REACH MY HEART...

IT'S HEAVEN ON EARTH

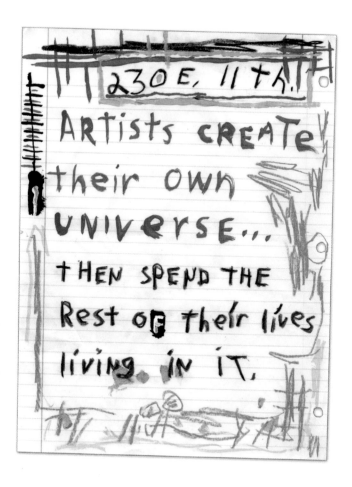

230 E. 11 th.

ARTISTS CREATE
their OWN
UNIVERSE...
THEN SPEND THE
Rest of their lives
living. in IT.

47

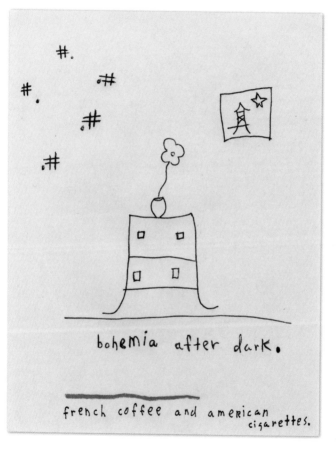

bohemia after dark.

french coffee and american cigarettes.

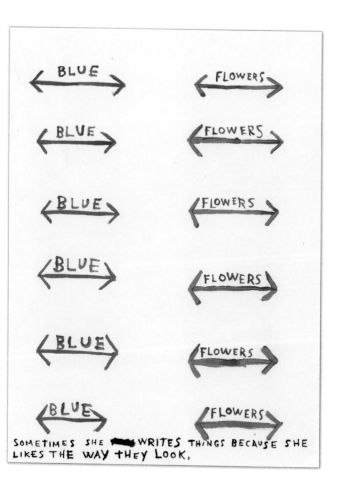

SOMETIMES SHE ~~WRITES~~ WRITES THINGS BECAUSE SHE LIKES THE WAY THEY LOOK.

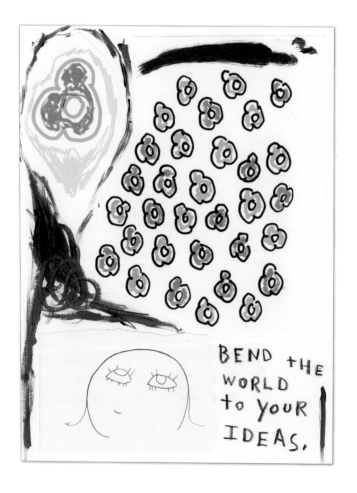

BEND tHE WORLD to YOUR IDEAS.

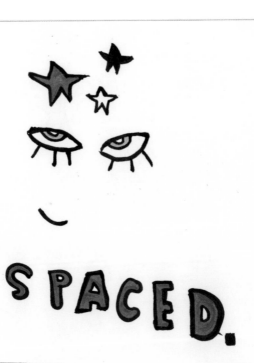

walking the STREET
at dawn...
sunlight as pale as
starlight.

we passed the bookstore
that never closes
and had coffee
at the place that's
always open.

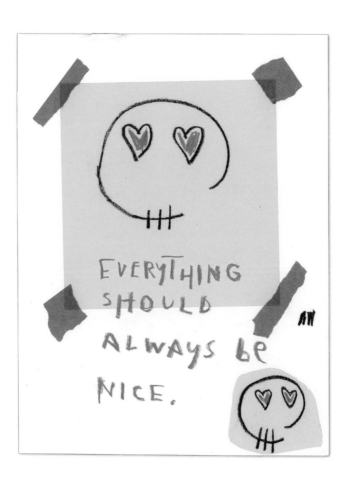

and she said...

⭐

people never
forget the
way you
make them
feel.

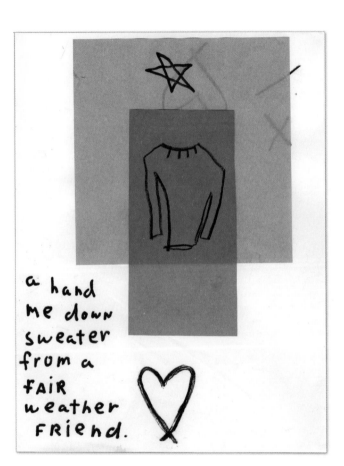

a hand
me down
sweater
from a
fAiR
weather
FRiend.

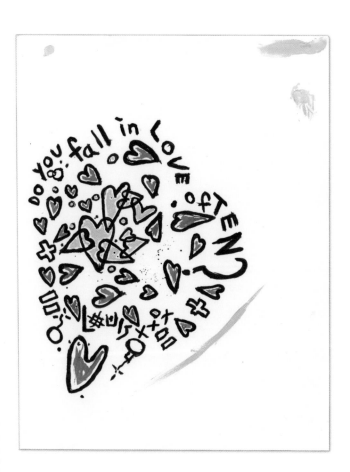

Do you fall in LOVE OFTEN?

61

artists
create their own
UNIVERSE

then...
spend the rest
of their lives

living in it.

I know a
SECRET about
a SECRET

SECRET

Love is Love and everything else is Everything else,

STAR          STAR

ABOVE THE WORLD,
"STARS AND
ANGELS NEVER FALL,

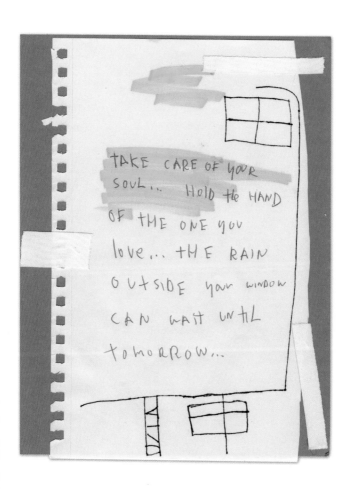

TAKE CARE OF YOUR
SOUL... Hold the HAND
OF THE ONE YOU
love... tHE RAIN
OUTSIDE your window
CAN WAIT UNtiL
tomoRROW...

# NOTHING FANCY

NOTHING FANCY

1. ASTROIogy

2. CRYSTALS

3. Kit-Kat WRAPPERS

NOTHING
Fancy

NOTHING FANCY
NOTHING FANCY

1. ASTROLOGY

2. CRYSTALS

3. Kit-Kat WRAPPERS

NOTHING
FANcy

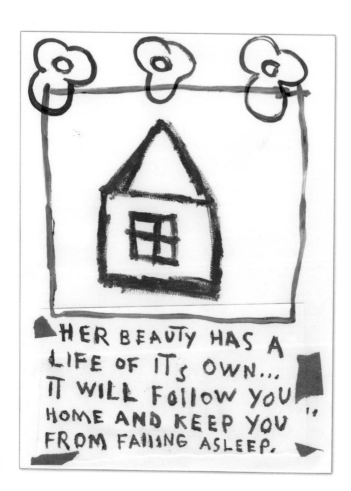

HER BEAUTY HAS A
LIFE OF ITs OWN...
IT WILL FOllOW YOU
HOME AND KEEP YOU "
FROM FAllING ASLEEP.

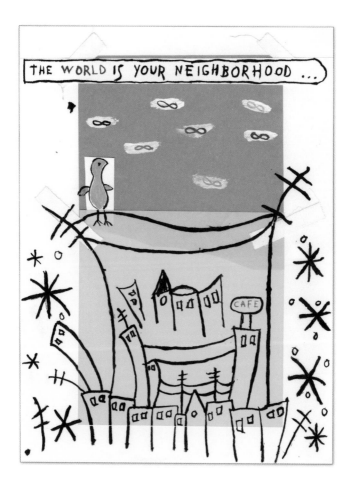

# FLOATING IN SEQUENCE...

ACROSS THE ROOM

SHE GIVES ME A SMILE followed by the smallest of WINKS.

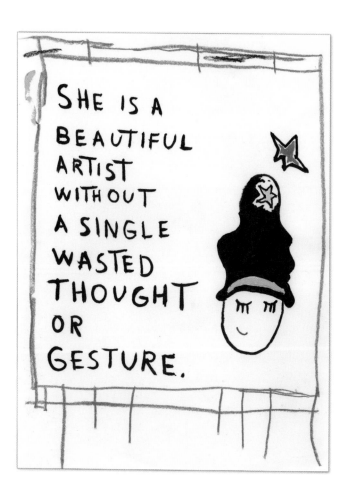

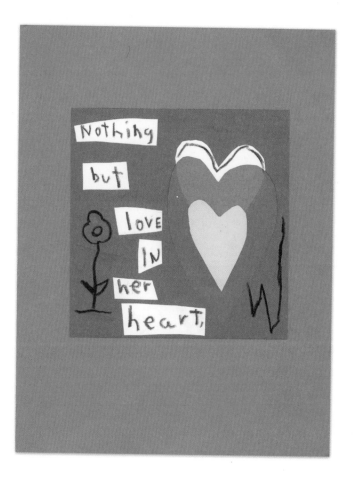

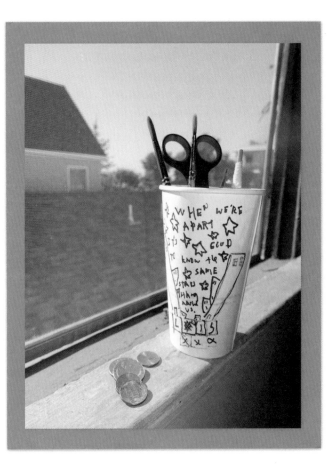

Andrews McMeel Publishing
a division of Andrews McMeel Universal
1130 Walnut Street, Kansas City, Missouri 64106

www.andrewsmcmeel.com

20 21 22 23 24 SDB 10 9 8 7 6 5 4 3 2 1

ISBN: 978-1-5248-6012-7

Library of Congress Control Number: 2020935802

Editor: Patty Rice
Art Director: Tiffany Meairs
Production Editor: Meg Daniels
Production Manager: Tamara Haus

ATTENTION: SCHOOLS AND BUSINESSES
Andrews McMeel books are available at quantity discounts with bulk purchase for educational, business, or sales promotional use. For information, please e-mail the Andrews McMeel Publishing Special Sales Department: specialsales@amuniversal.com.